IMAGES
of America

SONOMA COUNTY
WINERIES

This aerial view of central Santa Rosa looking south in the early 1950s reflects the growth of the Sonoma Wine Country's leading city and county hub near the midway point of the 20th century. This city, along with the entire Sonoma Wine Country, doubled in population during the second half of the past century, due in no small measure to the success of the wine industry.

IMAGES
of America

SONOMA COUNTY WINERIES

Thomas Maxwell-Long

ARCADIA

Copyright © 2001 by Thomas Maxwell-Long.
ISBN 0-7385-1906-5

Published by Arcadia Publishing,
an imprint of Tempus Publishing, Inc.
3047 N. Lincoln Ave., Suite 410
Chicago, IL 60657

Printed in Great Britain.

Library of Congress Catalog Card Number: 2001093334

For all general information contact Arcadia Publishing at:
Telephone 843-853-2070
Fax 843-853-0044
E-Mail sales@arcadiapublishing.com

For customer service and orders:
Toll-Free 1-888-313-2665

Visit us on the internet at http://www.arcadiapublishing.com

Chateau St. Jean became one of many new wineries that opened shop during the rebirth of the Sonoma Wine Country, which transformed its many valleys and hills during the 1970s and early '80s. As vineyards replaced dairy cows along many of the scenic drives through the Wine Country's back roads, Sonoma witnessed a sharp rise in the number of tourists. These new wineries were constructed with the visitor in mind. Large tasting rooms and picturesque picnic gardens became commonplace, along with detailed informative tours through the vineyards and cellars themselves.

Contents

Acknowledgments 6

Introduction 7

1. A Heritage Begins 9

2. Back in Time Around the Wine County 37

3. There's Hops in These Hills 63

4. A Land for Tourists, Festivals, and Family 69

5. Beauties, History, Harvest Fairs, and Napa Neighbors 95

Index 128

The Russian River in Sonoma County has since been a significant spot for tourists and local residents for many generations. This river is also one of the most popular salmon runs in North America, and many fishermen can be spotted along its winding banks and on its sandbars.

ACKNOWLEDGMENTS

All of the images in this book, with the exception of those of Ravenswood Winery, appear courtesy of the Sonoma County Library, Local History Annex.

Many thanks are required for the publication of this book. The first thank you goes to the editor, Keith Ulrich, for his suggestions and patience. Sonoma County Library Archivist Roxanne Wilson has been of the utmost assistance in this project from the start, before it was to become a book. Elizabeth Skemp of Ravenswood Winery was most helpful in sending the Ravenswood pictures, which were not available through the archives. Giancarlo Musso has given insightful advice throughout the research process on Sonoma County history, folklore, and on the wine industry heritage; his unmatched wine knowledge has proven invaluable. A special thanks to Bob and Luu Maxwell for the accommodations they have made for me during my information gathering in Sonoma. This book is dedicated to my loving wife, Roberta.

INTRODUCTION

Beginning 40 miles north of the San Francisco Golden Gate Bridge is the Sonoma Wine Country. In this land of rolling green hills, sprawling oaks, and towering redwoods some of the finest wine in the world is made. The Mediterranean weather that offers abundant rains in the winter and a long hot sunny summer, is the perfect climate for growing grapes, and that is exactly what is done throughout the many valleys that comprise this county.

The first occupants of Sonoma were Coastal Miwok, Pomo, and Wappo Indians. For nearly five thousand years, these tribes lived in such a harmonious fashion with nature that it is nearly impossible to find any artifacts from their past. The first contact that these Native Sonomans made with Europeans came in the 16th Century, when Sir Francis Drake put ashore along the southern Sonoma coastline for provisions and repair work on his vessel. The next encounter came with the arrival of the Russian fur trappers that set up camp in the north, and established Ft. Ross. Within a generation of the Russian colony, the Spanish and Mexicans arrived in what is now the town of Sonoma. The California Gold Rush in 1849 through 1850 brought in peoples from all points around the world, and essentially brought California into the Union. As the Indians were either forced out or killed, the Americans occupied the land and their number climbed each year. During the entire process the Americans learned of the unique array of climates throughout the many valleys of Sonoma that were conducive for many types of agriculture, in particular viticulture.

Beginning in 1857 with the Buena Vista Winery and continuing up to the present, Sonoma became one of the preeminent wine making regions in the world. Sonoma was not just the birthplace of California winemaking; it was also the birthplace of the California Republic in 1849 when the Bear Flag Revolt took place in the town of Sonoma. Over the course of the next 150 years, hundreds of wineries would open, as their proprietors would try their hand at making the next great California wine. There were many trials along the way, from earthquakes and wildfires to Prohibition. Most from the early days fell to the wayside, though some survived and continue to flourish. There are essentially three discernable periods in the Sonoma Wine Country history. The founding stage was in the second half of the 19th century up to Prohibition. The second was from the post-Prohibition period up to the early 1960s, and the third takes us up to the present. Along the way, the Sonoma Valley became one of the most frequented tourist attractions in the state of California. By the end of the 20th century, over a million visitors traverse the winding roads throughout the county each year, and their numbers continue to grow.

This book offers a pictorial history of the Sonoma Wine Country, its many wineries, vineyards, and the towns and townsfolk that grew up alongside the development of this fantastic agricultural enterprise in one of the most beautiful places in the United States, and perhaps the entire world.

One
A Heritage Begins

Buena Vista Winery was founded in 1857 by the eccentric Count Agoston Haraszthy, who by some accounts, had actually been a self-appointed Count. It is the oldest winery in California, and the original stone cellars now serve as the winery's tasting room, which houses an outstanding collection of art and memorabilia. Located in the western section of the town of Sonoma, Buena Vista continues to be one of the leaders in the industry in now its third century. From this picture of one of the early harvests it looks as though a few more horses and wagons would have come in handy. This photo was taken in 1870.

The original buildings of the Buena Vista Winery were constructed out of the raw materials that were gathered from the immediate surroundings. The abundant stone, oak, and redwood went into the construction. This is one of the original buildings erected during the proprietorship of Count Haraszthy. The photo was taken in the 1920s during Prohibition.

The restoration process for some of Buena Vista's historical buildings began in the 1950s. This 1952 picture of the winery was taken before serious restoration work began. The excellent condition of the exterior demonstrates how well these buildings were constructed nearly 100 years prior.

This image is of the Buena Vista Wine Cellar as it appeared just after the end of Prohibition, in the early 1930s.

The oak-lined paths along the picnic trails at Buena Vista have been a popular spot for tourists for nearly 150 years. The winery buildings with their thick, castle-like, stone walls provide ample insulation from the hot summer Sonoma sun. Located outside the town of Sonoma in the Valley of the Moon, there was a distinct necessity to safeguard the precious wines from the extreme temperatures that have been known to push the mercury into the century mark for a week at a time. This picture was taken in 1952.

It is hard to imagine the Buena Vista Winery without the abundance of tourists and wine enthusiasts that now flood onto its vast estate. This picture was taken in 1950.

Much has changed at Buena Vista Winery since this office building was the business center at the beginning of the 20th century.

14

This 1910 postcard advertisement of Buena Vista Winery proudly boasts of the winery's status of being "California's Oldest Winery," which was nearing the 60-year mark at the time of this card's release.

In addition to simply being the oldest winery in California, Buena Vista is the oldest stone winery in the state. One can only imagine how proud Count Haraszthy would be if he could see how long his vision of producing great wine in Sonoma has lasted. This postcard is from the 1950s.

In 1862, Korbel Champagne Cellars was founded and during its long life has maintained the premier spot in the United States as a producer of sparkling wine. Korbel is located in the Russian River Valley, and its picturesque buildings are framed by one of the most breathtaking locales in the entire Sonoma Valley. This image of the Korbel Vineyards was taken in 1910.

The Korbel vaults has been a favorite spot for tourists during their meandering through the Wine Country. The millions of cases that Korbel produces each year all come out of these famed vaults. This picture was taken of the vaults in 1939.

One of the more famous tasting rooms in the Wine Country is Korbel's Champagne Cellars. Little has changed on the Korbel façade since this image was taken in 1935, except that it is nearly impossible to view the tasting room without a parking lot full of cars.

This impressive structure is the Korbel distillery. The picture was taken in 1910.

These many racks of Champagne were photographed in 1956. It is difficult to imagine the many millions of bottles that Korbel rolls out each year, and in 1956 it was estimated that 500,000 cases had been produced.

This picture was taken in 1888 of some of the early patrons of Korbel, clearly enjoying a relaxing afternoon in the gardens.

This late-1940s aerial picture of the greater Korbel vineyards along River Road contains only a small portion of the many acres that were utilized a half century ago by California's leading champagne makers.

When this picture of Korbel was taken in 1970, Richard Nixon was the country's chief executive and a future president was the governor of the state of California—Ronald Reagan. The radio waves in Sonoma were filled with the sounds of The Doors, The Grateful Dead, and Joan Baez.

The Korbel champagne cellars are seen here in 1965 at the start of the great expansion of their business that has continued up to the present.

Geyser Peak is one of the few remaining 19th century wineries. This picture captures the foundation being laid in 1880. Geyser Peak, which has gone through many stages during its long tenure in the Alexander Valley, today is not only one of the largest bulk producers in Sonoma, but it is also one of the purveyors of some of the finest wines to come out of the county.

This is an interior view of the cavernous Geyser Peak Winery in 1890. The dirt floors are certainly a part of the past, but the grand oak barrels used for aging the wines remain a part of the winery. From time to time, handlebar mustaches can be seen as well, depending on the fashion trends.

This 1910 picture was taken to commemorate the completed construction of the Geyser Peak Wine and Brandy distillery in that same year. Brandy, along with other beverages, was distilled not just by Geyser Peak, but by numerous wineries from the beginning, though wine has always remained on the top of the list.

The massive aging barrels of Geyser Peak Winery in 1905 were constructed of oak and stood nearly three stories in height. Today, it is a common feature of most large wineries, though at the dawn of the 20th century these barrels certainly caught the attention of the visitors.

In 1903, both John Black and Old Buck were hard at work at Geyser Peak, making sure that the precious grapes made it into the crush and that the bottles of wine found their way safely into the stores.

This is a southern, roadside view of the main entrance of Geyser Peak Winery in 1910. The large building on the left housed the massive aging barrels, and its interior was a favorite spot of the tourists for taking pictures.

The interior of the business office of Geyser Peak Winery in 1889 reveals that the Sonoma Oak was not used simply in the construction of wine barrels, rather nearly all parts of the office had been made from this abundant natural resource.

From its inception, Geyser Peak Winery was meant to be a bulk wine producer, which in the 19th century meant serious attention to detail. The professionals that made up the business staff were experts in their respective areas of endeavor, and their serious nature is evident in both their dress and demeanor, although making great wine has its rewards that simply go beyond the profits. This picture was taken in 1889.

Simi Winery was founded in 1867 in the town of Healdsburg, in northern Sonoma County. Located conveniently along the Southern Pacific Railroad lines, Simi was able to take advantage of mass transportation early on. As the town of Healdsburg grew both in population and popularity amongst tourists, Simi found greater levels of success. With location being of great significance in determining the success of a business, the founders of Simi made a keen decision in locating their winery in Healdsburg, a city with tremendous natural beauty, a large central plaza, and easy access via the trains and roads to San Francisco. This picture was taken of Simi in 1934.

These 1945 pictures are of the wagon rides that would take the tourists along the trails through the hillside vineyards of Simi Winery. With all that dust being kicked up it appears as though these rides must have taken place during the warm, dry summer months.

29

In 1915, a massive train derailment occurred directly in front of Simi Winery. Through newspaper pictures of this unfortunate incident, Simi Winery found itself on the front pages of many western daily newspapers. It took nearly a week for the Southern Pacific to clean up this mess, even though they had received assistance in their effort by the employees of Simi and many local townsfolk.

Stacks of baskets are seen here at Simi in 1952, awaiting the call to be filled with grapes just before the crush that year.

Here are the Simi Vineyards as they appeared in 1948.

When this picture was taken of the town of Sonoma in 1913, Sebastiani Vineyards was already an established name in winemaking. Over the course of the next century, this town and the Sebastiani Vineyards would grow. This view down Napa Street would be transformed during the 20th century into the premiere stop for wine enthusiasts and tourists in the entire Wine Country of Northern California, and the Sebastiani family would have much to do with the entire process.

Currently, on any given day, these same Sonoma streets are filled with tourists. The town of Sonoma acts as the hub of the Wine Country, and is located almost exactly in the middle of the counties of Napa and Sonoma. Highway 12, the unofficial "Wine Highway" runs through its central plaza, which is the largest of any of the cities in California that have that particular design. The tasting room and shop-lined streets have proven to be the perfect design for tourists to stroll along and enjoy a relaxing day. This picture was taken in 1905.

This view of the artistic stained glass window of the Sebastiani tasting rooms speaks of the fine attention to detail that has made their wines one of the top premier selections for many generations, as well as a fantastic ambiance that people enjoy nearly as much as their wine.

These barrels are from the early days of Sebastiani Vineyards. There is no doubt that each was one day filled with some of the best wine to have ever come out of California. This picture was taken in 1894.

This 1975 picture captures the two more recent generations of the Sebastiani family, August and his son Sam, outside the front entrance of the winery. Sam, along with his wife Vicki, went on to found their own winery, Viansa, (derived from Vicki and Sam) which has proven to be one of the most respected fine wine producers in Sonoma.

Here are Sam, Don, and August Sebastiani in 1975. The family, well known for their philanthropic work throughout Sonoma, have among other notable gestures refurbished the old town theatre, which was aptly named in their honor. The theatre is located in the central plaza.

One of the many pickers is preparing to harvest the Sebastiani grapes in 1912.

Two
BACK IN TIME AROUND THE WINE COUNTRY

Sonoma County not only provided the wine makers with an ideal climate for their enterprise, but also an abundance of natural resources, such as indigenous oak and granite. These Italian block makers at the Wymore Quarry at Annadel provided the growing wine economy with sufficient materials for the construction of hundreds of wineries throughout the many valleys that make up the Sonoma Wine Country. This picture captures their efforts in 1905, the year prior to the Great 1906 Earthquake that brought many, though certainly not all, of the structures in North Bay down.

Though wine was at the heart of Sonoma, many other beverages were consumed around the county. This 1900 picture of the interior of a saloon also reminds us that this highly cultured community was still, at the beginning of the 20th century, connected to its western tradition.

Could this 1886 picture be of the "little engine that could?" Or is it merely the Tyrone Engine on display in Duncans Mills?

Many celebrities have made Sonoma their home over the years. The natural beauty of the land, pleasant climate, and laid back culture are heavy influences. Jack London, seen here in 1904 atop his trusted "Belle," was perhaps one of the earliest to have built a ranch in the rolling hills.

With all of the money that was being made around the county there was more than sufficient need for several banks and countless other enterprises that made the gentile life in Sonoma all the more pleasurable. This picture was taken of the Silk Brothers and Analy Bank in 1915.

The growing demand for more wine led to the removal of many redwoods throughout Sonoma County, which in turn served as materials in the construction of homes and businesses. Clear cutting of the redwoods to be replaced by a vineyard was captured on film in 1904.

The Santa Rosa Street Fair has a long and distinguished history. Farmers and merchants provided a cornucopia of tasty and intriguing items for consumers in a creative fashion. This one took place in 1906, just before the earthquake that literally leveled the downtown.

Well-known for its year round temperate climate, snow scenes such as this one in Guerneville in 1900 are indeed a rarity, but do occur at least a few times each century.

The Bottasso and Sons Winery and Wholesale liquor store is seen here as it appeared in 1940.

This snowfall scene in Santa Rosa at 4th and Hinton was recorded in 1947.

As the 20th century progressed, more and more resorts were built throughout Sonoma. This 1946 interior view of the Rustic Inn captures the sentiment that many of the developers held onto throughout the past hundred years—that of remaining connected to the western heritage of this coastal community. Some have gone a little overboard with the western regalia from time to time.

In the 50 years after Count Haraszthy founded the first winery in Sonoma, over two hundred others have tried their luck in this trade; some have succeeded, though most have gone the way of antiquity. This 1911 picture of the J. Chauvet Winery records just such a piece of Sonoma's past.

Tourists need a place to sleep! This 1909 picture is of one of the finer hotels in its day, the Hotel Mervyn—one of the many that opened for business at beginning of the 20th century.

The town of Glen Ellen was more than just the home of Jack London. Located nearly equidistant between Santa Rosa and the town of Sonoma, though somewhat off of the beaten path, it has been a favorite vacation spot for over a century; understandably so with business centers such as this one that contain not only a post office but a saloon as well! This picture was taken in 1906.

The town of Sebastopol lies to the east of Santa Rosa, and has historically been known for not only being an important part of the Wine Country, but it has for many years been the center for apple orchards in the county. This image of that town was taken in 1887.

The Apple Festival in Sebastopol has long been part of the history of that town, though in recent years the focus within the agricultural community has moved away from that particular fruit, to the chagrin of many townsfolk. This particular apple show was in 1911.

This group of Kenwood women had been on their way to a harvest fair in 1911 when this picture was taken. The town of Kenwood is located between Glen Ellen and Santa Rosa along highway 12, and has been a center for winemaking for over a century. Over the past 25 years it has become a must stop for those touring the Wine Country, as some of the more popular wineries that have opened during the past generation such as St. Francis, Kenwood, and Landmark have made this community their home. In fact, Tommy and Dick Smothers of the *Smothers Brothers* television show fame even tried their hand at winemaking for over decade; their winery was located in the town.

This 1910 picture is of a typical Kenwood family, perhaps enjoying a sunny afternoon.

The J. Pedroncelli Winery, which was founded in Sonoma in 1904, has long been a significant member of the winemaking community. It has also remained for a family operation since its inception. This 1935 picture is of the Pedroncelli family harvesting their grapes.

This is the Pedroncelli Vineyard in 1934 with several of the family members at work.

This 1920 picture of the Valley View Winery captures for posterity one of the many wineries that did not survive the long Prohibition. If Prohibition had not occurred, it is safe to assume that many more wineries from this earlier era might still be with us today. Some of these ghosts of the past have left behind more than photos of their existence, as new wineries have sprung up from their abandoned vineyards throughout Sonoma and in other parts of the California Wine Country.

As Franklin Roosevelt effectively ended Prohibition, another crisis for the wine industry had already begun—the Great Depression. This 1935 photograph of the Daddi family reflects their ability to stave off the effects of the economic disaster better than most. Sonoma, like other parts of California during this period, was flooded by an influx of families in search of work. Unlike many other parts of agricultural California, the Wine Country actually needed an increase in its labor force due to the sharp increase in demand for the beverages that it produced following the end of Prohibition.

This 1880 picture is of the Thomas Kearns Winery, another ghost from the past in Sonoma.

The now defunct and abandoned Orr's Winery is shown in this 1908 picture. Towering in the background is Mt. St. Helena.

This is the Lachman and Jacobi Winery in 1908, another one of the many wineries that was not able to outwait Prohibition.

51

The Camm and Hedges Lumber Company was able to reap the benefits of the expanding wine industry and population growth of Sonoma County during the first part of the 20th century. This picture of their enormous facility is from 1908.

Presentation of the products has for many years been an important part of sales. This 1905 picture of a Summit Peak Vineyards creative display would make even the most difficult-to-please merchandiser smile with approval.

The Seghesio Winery is another Sonoma family winery. Their place in history can be traced back to the 1890s, when they had started out in the business as grape suppliers to other wineries. Having survived Prohibition, the family moved directly into wine production. This 1935 picture is of the Seghesio family home at their winery.

Not all families were able to afford such opulence as the Seghesio family. This 1907 picture of a Sonoma family on their porch was reflective of the normal standard of living of the day. Even though the house itself might not have been extravagant, as those who have had the pleasure of walking through the redwood groves will note, life among the great trees can be quite gratifying. The house itself was built with planks from the redwood trees.

This is a typical Santa Rosa home in 1870, with three lovely ladies making it all the more attractive.

In the year that this photo was taken of Murphy's Sawmill, 1880, Geyser Peak Winery was founded and much of the wood that supplied the construction of their buildings was ordered from Murphy's.

A popular stop for many men in Sonoma was Bailey and Bailey Cigars and Tobacco. This picture of Bailey and Bailey was taken in 1908.

Weather that is conducive to growing grapes and apples is also quite agreeable for many other fruits. This is the Sheriffs Brothers Fruit Company as it appeared in 1908.

Valley of the Moon Winery today looks nothing at all like its original buildings that appear in this 1942 picture. Recently the winery built a new tasting room and designed new gardens and grounds for its visitors, which rival most of the other better-known producers in Sonoma County. Today, they are part of the prestigious Korbel winemaking group.

At the time of this photograph of Nervo Winery in 1952, the wine industry was about to undergo another major period of re-birth and growth. Unfortunately for Nervo, they were not to be a part of the success story, as they too became part of the Sonoma past.

This 1905 picture is of a now defunct, unknown winery that made an unsuccessful attempt at challenging Korbel at champagne making in Sonoma.

This 19th century winery, named the Madrona Knoll Ranch, was photographed in 1890 by the proprietors for posterity, which is all that now remains of this venture.

Kenwood's newly completed Stone Depot in 1910 was the major point of entry to that town for next decade. However, when the automobile craze began, the golden age of the railroad soon departed.

The 1906 earthquake that brought San Francisco to its knees literally leveled Santa Rosa and most of Sonoma County. This 1906 image tells of the horrors that befell the Wine Country during that disaster. Through the strength of its residents it would rise again, and within one year it was difficult to tell in most areas that such a temblor had actually occurred.

The Rincon Valley area of Santa Rosa is the westernmost section of that city, and today is one of the more established family-oriented neighborhoods. Rincon Valley, like many other parts of town, had originally been part of the agricultural community of Sonoma County. In this 1885 picture of the Metzger Winery, many residents of Rincon Valley might recognize the surroundings that are now filled with neighborhoods.

The J. Shaw Winery, pictured here in 1878, was another of the Rincon Valley wineries.

This 1903 picture is of an unknown winery near Lytton, along the Northern Pacific Railroad lines.

Sonoma has a long tradition of warm spring retreats and tonic farms throughout the county. This 1890 picture, however, is of the Santa Rosa Poultry Association. Note, on the side of the covered wagon is an advertisement for a poultry tonic and conditioner! Only the most trusting of people might have tried that one for themselves or their hens.

Women's swimwear fashions appear to have changed tremendously since this 1927 photo of women enjoying themselves at the Russian River.

The Russian River continues today to be the most popular spot when the summer heat pushes the temperature up. This family appears to appreciate the river in this 1941 picture, just past the town of Monte Rio heading towards the Pacific Ocean.

Rhododendrons have nearly always been a common site throughout Sonoma County, though it is difficult to tell from the expression of these Sebastopol residents whether they are at all satisfied with this crop in 1943.

Three
THERE'S HOPS IN THESE HILLS

The Sonoma Wine Country has also been home to a large-scale hops industry. Beginning in the 19th century, hops has been one of the favorite crops throughout the valleys. In recent years, the growth of the microbrewery popularity has brought this Sonoma tradition back as many vintners have found enough spare time to develop a few lines of beers and ales from Sonoma-grown hops. As this 1910 picture of a couple weighing their hops shows, this is a crop that can make one downright "hoppy"!

Much of the hops in this 1910 picture probably found their way into the brewhouses located around the San Francisco Bay Area.

The hops might have left Sonoma County for brewing purposes, but sooner or later they found themselves back in the county, filling the mugs of saloons like the ones in Santa Rosa. This picture was taken in 1910.

Much of the hops that were grown in Sonoma were processed and brewed locally. This 1890 picture is of a delivery wagon heading out to the town of Bodega.

Hop Kilns were much more common during the late 19th and early 20th century than they are today. Prohibition had essentially killed the industry, which unlike the wineries, was unable to continue production during the years when domestic sales of alcoholic beverages were forbidden. This picture was taken in 1919.

The climate and soil made hops growing a relatively easy endeavor. Sonoma attracted many people over the years that held dreams of growing bumper crops of all kinds. Famed botanist Luther Burbank, pictured here in 1920, made Santa Rosa his home and laboratory for inventing many new varieties of plants.

In addition to making Luther Burbank's home and gardens a California State Historical Landmark, the kind folks of Santa Rosa named one of their schools after him in 1920, showing Mr. Burbank how much appreciation they had for his years of toil and success.

This 1939 picture of old abandoned hop kilns in Guerneville is a reminder of the impact that Prohibition had on the county.

In 1896, when this picture was taken, the hops industry was still hoppin'; these hops pickers are wearing hops garlands on their hats—nothing beats a harvest festival!

This hop kiln near Dry Creek Valley was photographed in 1870.

This hop kiln outside of Healdsburg was photographed in 1900.

Four
A Land for Tourists, Festivals, and Family

As early as 1849, during the California Gold Rush, emigrants and immigrants found their way into this hospitable land. Many of those early settlers were in search of a life that would afford them the opportunity to improve their social and economic status though hard work. Others were in search of the adventures "out west" that had been circulating throughout the world, due to the discovery of gold in that year. The Spanish had essentially westernized Sonoma and Mexican California two generations prior to the flood of people that followed the Gold Rush. This made it appealing to those in search of a new home to raise a family in. This 1852 picture is of a woman in typical travelling clothes during that initial Americanization period.

The Gold Rush brought in immigrants from around the globe. By the 1860s Santa Rosa had a sizeable Chinatown, and by the end of the 19th century hundreds of Asians had settled in Sonoma. In this 1900 picture is Kemp Van Le Chung, a resident of Santa Rosa in that city's youth.

This is an 1895 picture of a Chinese family in Santa Rosa.

(Top) In this 1900 picture is the former Santa Rosa resident Jim Poy, a native of China who lived out his years in Sonoma.

(Middle) When the 1906 earthquake demolished Santa Rosa, it took that city's Chinatown along with it, as this 1906 picture demonstrates.

(Below) The Alexander Valley Bridge, that was that part of the county's connecting point, was destroyed in the 1906 earthquake as well.

Within a couple of years after the 1906 quake, business throughout Sonoma was recovered and moving forward. By looking at this 1909 photograph it is difficult to imagine that these buildings were erected on the ruins from the quake just two years before.

Sonoma County's Petrified Forest has been a popular spot for tourist for many generations. This picture was taken in 1924.

72

The petrified tree in this 1924 picture was aptly named "Queen of the Forest."

Though the redwood trees are impressive in their petrified state, they are even more majestic while they remain vertical, as the people in this 1952 picture are clearly captivated by the great trees.

Armstrong Grove, which is located in Guerneville, contains some of the tallest trees in the world. Each year this grove of redwoods draws in visitors by the thousands who come to see the 300-foot tall behemoths that do not grow anywhere else in the world. This picture of Armstrong Grove was taken in 1938; since then the trees have only grown taller!

The Italian Swiss Colony in the town of Asti had been one of the top tourist attractions in Sonoma. This is the exterior of the tasting room at the Italian Swiss Colony in 1940.

The vineyards in Asti date back to the 19th century. This picture of the Italian Swiss Colony's grapevines was taken in 1902.

The sense of humor of the Italian Swiss Colony founders was apparent when they built this church named La Madonna Del Carmine in the shape of a wine barrel. This picture was taken in 1952.

In this 1912 picture at the Italian Swiss Colony, the train is being loaded with wine to be brought to the ports in San Francisco, 60 miles to the south.

This postcard of the grapevines was sold at the Italian Swiss Colony gift shop in the 1950s.

These are some of the discarded wine barrels from the past season at the Italian Swiss Colony that were sold to tourists as yard and patio décor in the 1950s.

The wine vaults of the Italian Swiss Colony rivaled any in the land in terms of size. This picture was taken in 1950 during the peak of the Italian Swiss Colony's production.

The Santa Rosa Ursuline College, pictured here in 1928, was one of the institutes of higher education in Sonoma County in the first half of the 20th century.

The Santa Rosa Royal Arcanum Society Council #2045 poses for this 1909 picture for their annual memorial portrait.

The Salvation Army has had a strong representation in Sonoma for nearly a hundred years. These pictures are from the year 1909.

The Salvation Army house as it appeared in 1909.

In this 1910 picture is one of the largest congregations in Sonoma County, St. Rose Church, which has continued to be a force in the community up to the present day.

As strange as it might sound, this 1892 picture is of the Arsenic Beauty baths that were found in Sonoma during the late 19th century. Some people will try almost anything!

The Shriners Band performs in front of the Sonoma County Courthouse in this 1926 picture.

The Grand Hotel was one of the best and most popular in all of Sonoma County. This picture of that hotel was taken in 1924.

Parker & Gordon, Grain and Feed store dominated the market in Sonoma County for nearly an entire generation. This picture of their enterprise was recorded for posterity on January 1, 1900.

83

At the time that this photograph was taken in 1935, the Sonoma Stage Coach was no longer the preferred mode of transportation, except for tourists who were looking to have some fun and remember the "good old days" during their vacation in the Wine Country.

This view from atop Cemetery Hill in Guerneville in 1912 shows how that town had grown from a few hundred souls to a few thousand in the course of two generations. Guerneville was a town that recognized the economic significance of the Wine Country early on; not simply in terms of wine production, but as a potential tourist center for those looking to escape the big cities for a relaxing vacation under the warm Sonoma sun.

In the early years of the Sonoma County Fair, boxing contests were held. These two contestants from the 1907 event appeared ready and willing to get into the ring and slug it out for the cash prize, which reached $100.

85

Downtown Santa Rosa, Sonoma's county seat, is shown here as it appeared in 1911. The view is from the corner of 4th and Hinton, looking west. Much has changed since this picture was taken; in addition to more cars being seen on the roads today, the downtown has many more trees and much wider sidewalks, proving that some cities can become more beautiful and pedestrian-friendly as they age.

This 1911 view down 4th Street in Santa Rosa is from D Street.

86

This 1925 picture faces north on Mendocino Avenue, from the downtown of Santa Rosa.

This image was taken ten years later in 1935. The businesses in this Mendocino Avenue picture are Montgomery Wards, and the *Press Democrat* newspaper.

87

These two 1941 pictures were taken on the corner of 4th and Mendocino in the Santa Rosa downtown.

The Monte Rio Hotel, pictured here in 1910, had been the most significant hotel in the town of Monte Rio. Situated along the shores of the Russian River, just east of Duncans Mills, Monte Rio became known as the Vacation Wonderland of Sonoma. In this quaint town, just a few miles from the Pacific Coast, boat rides and rentals were a popular form of amusement, as were hikes through the redwood groves. Just a few miles down the road from Monte Rio lies the Bohemian Grove, an exclusive, "men only" retreat that has continued to operate up to the present day.

The Monte Rio beach has always been one of the most popular beaches along the Russian River. This scene was recorded in 1928.

The Monte Rio Carnival in the early part of the 20th century was a tremendous event. In this 1909 picture are the Queen of that year and her maids.

The refreshment stand in Monte Rio had an endless line of patrons in the summer months. The summer of 1908 was recorded with this snapshot.

All vacations must come to an end, which in most cases in Monte Rio meant departure from the Vacation Wonderland via train in 1901.

91

When the automobile age arrived, more and more garages began to open up around Sonoma. This 1933 picture is of the A.L. Bowlsby Standard Oil Products in Glen Ellen.

Some people are just not willing to completely change with the times, as this 1940 picture from the town of Penngrove indicates.

One of the earliest of the Sonoma garages is pictured here in 1911.

93

Seen here is the Mont La Salle Novitiate and its vineyard in 1932, located in one of the most picturesque areas of the Wine Country.

The end of the Great War had arrived, and the central Santa Rosa train station was flooded in 1919 with the families and loved ones of the soldiers who were returning from the European front.

Five
BEAUTIES, HISTORY, HARVEST FAIRS, AND NAPA NEIGHBORS

The Miss Sonoma County beauty contest has long been one of the more talked about summer events in the county. With a hundred-year history behind it, and its popularity still going strong, it is not hard to imagine another century of continued success. This 1953 picture is of Gloria Brodie, Miss Sonoma County of that same year.

In 1962, Sonoma Mayor William Raymond and his wife Audrey were able to gain federal recognition for the Sonoma Plaza as a National Historic Monument in remembrance of California gaining its independence from Mexico in the Bear Flag Revolt. In the following year, Audrey was selected as one of the "Outstanding Women of Sonoma" for her contributions in public service, the arts, the business world, local history, and hospitality. The couple is pictured here aboard the *Queen Mary* luxury ocean liner.

```
WU9 ( O FPA054) ( FP126) LONG   NP826 YHA003 GOVT NL PD=
                          YH HYANNIS MASS SEPT 15=
HONORABLE WILLIAM G RAYMOND, MAYOR=
     SONOMA CALIF=
I REGRET THAT I WILL BE UNABLE TO PARTICIPATE PERSONALLY
IN THE DEDICATION OF THE SONOMA PLAZA AS A NATIONAL
HISTORIC MONUMENT ON SEPTEMBER 24, BUT HAVE ASKED STATE
SENATOR JOSEPH RATTIGAN TO ATTEND AS MY PERSONAL
REPRESENTATIVE ON THIS OCCASION. I WANT TO EXTEND MY
GREETINGS AND BEST WISHES TO EVERYONE PRESENT AT THE
DEDICATORY CEREMONIES.

     I AM WELL AWARE OF THE ENDURING SIGNIFICANCE OF SONOMA
IN THE CIVILIZING OF THE NATION'S WESTERN FRONTIER, IN ITS
RICH CO-MINGLING OF AMERICAN AND SPANISH CULTURES, AND IN
THE LAYING OF THE CORNERSTONE OF CALIFORNIA'S INDEPENDENCE
YOU HAVE EVERY REASON TO BE PROUD OF THAT HERITAGE AND
EVERY CAUSE TO BE RESOLUTE IN AFFIRMING FOR THE FUTURE THE
VALUES AND PIONEER VISION NOURISHED IN YOUR COMMUNITY. I
KNOW THAT WITH THE DEDICATION OF PRESENT DAY CALIFORNIANS
AND THE DETERMINED PUBLIC LEADERSHIP OF MEN LIKE GOVERNOR
BROWN, SONOMA AND THE VIGOROUS STATE THAT HAS DEVELOPED IN
THE 115 YEARS SINCE THE BEAR FLAG REVOLT WILL FLOURISH IN
THE FUTURE EVEN MORE GREATLY THAN IN THE PAST=
     JOHN F KENNEDY=
     (908A)
```

The 1962 Western Union Telegram from President John F. Kennedy congratulates Mayor Raymond on securing the Sonoma Plaza as a National Historical Monument.

The 1939 Miss Sonoma County Apple Parade is shown here on its way through town.

The great effort that went into constructing the Juvenile Queen's Float and the costumes of those aboard is apparent in this 1915 picture.

In 1960, Hollywood star Jayne Mansfield came to the Wine Country of Sonoma for a weekend of publicity, fun in the sun, and hopefully a little rest and relaxation after all the work was done. She is pictured here at the Flamingo Resort in Santa Rosa, one of the flagship resorts of the Wine Country, located at the juncture of 4th Street and Highway 12.

The Flamingo Resort and Jayne Mansfield appear to have been made for each other.

Many of Jayne's fans turned out to greet her at the Flamingo, so many in fact that security personnel at the resort had their hands full for the entire visit.

Ms. Mansfield was able to take in the auto races at the Sonoma County Race Track, though the winner of the event appears to be more thrilled in meeting the screen legend than in having won his race!

The automobile races have had a distinguished history in the Wine Country. In this 1953 picture is Gym Khana in his roadster at the Montgomery Village Shopping Center in Santa Rosa.

The midget races at the Santa Rosa Race Track have been a welcomed event each year. These pictures are from the year 1939.

104

This midget race is from 1935 and was held at the Santa Rosa Race Track.

Festivals and celebrations include friends and neighbors. This 1939 picture is of Mrs. Beringer from Napa County's Beringer Winery as she breaks a bottle, christening the lead float for the harvest fair of that same year.

Fashion and high society found their way into the Sonoma Wine Country. Pictured here is a fashion show at the Topaz in 1959.

The Flamingo has been the home for many fashion shows over the years. The latest leisure outfits of 1960 were being modeled in this picture.

The art deco styling of the Flamingo Pool area was a natural spot for this swimwear modeling-photo shoot in 1959.

The 1959 Miss Sonoma County candidates and judges are shown here.

As the Sonoma Wine Country flourished after the repeal of Prohibition, the local politicians took to the skies in this 1933 picture.

The celebrations at the Fountain Grove Winery, one of the great wineries of Sonoma from a bygone era, were always one of the biggest events in the county, pictured here in 1954.

The cooks do not appear to have complete faith in the food as this candid picture reveals. Hopefully the guests did not have the same reaction.

This image takes us inside the sampling room and office of the Fountain Grove Winery in 1930. The wineries that remained open during Prohibition were able to sell their goods abroad and to religious organizations (to be used in church services). This was a considerably smaller market then the general public and many wineries fell by the wayside because of the government restrictions.

Pictured here in 1950 is Paul Verdier of the Fountain Grove Winery. Mr. Verdier was a commanding figure in the Sonoma Wine Country for many years—his passing and the passing of Fountain Grove Winery signaled the end of an era for the Valley of the Moon.

North Coast Chamber of Commerce Director V.M. "Bob" Moir dedicates the new Hacienda Bridge in 1942.

Sonomans did not take Prohibition lightly, and when word got out that Franklin Delano Roosevelt, the 1932 Democratic Party candidate for president, was a "wet" candidate, a renewed spirit filled the county. This 1932 picture leaves no doubt as to which side of the issue the driver of this vehicle stood on the matter of Prohibition!

Though Napa came to the wine producing party later then neighboring Sonoma County, they have made quite a name for themselves in the process. The friendly rivalry between the two leading fine wine counties has been in motion literally since Napa became home to some of the great wineries in the mid-19th century. As the saying around the Valley of the Moon goes: "Sonoma is for wine, Napa is for auto parts!" The Christian Brothers Winery of Napa was founded in 1882. This picture of their winery is from their 80th year in operation in 1962.

This is another view of the gothic Christian Brothers Winery from 1962. The winery was well known around the world; it is even highly respected in neighboring Sonoma.

This is the opulent interior of the Christian Brothers Winery tasting room in 1962. The ornate woodcarvings that make up the bar area and the walls have drawn many admirers over the past century.

115

Far Niente Winery in Napa was founded in 1885. The winery has a reputation for producing not just some of the most expensive wines to come out of California, but also some of its very best. It is not as well known as some of its neighbors, but held in high regard by those whose discerning palates call for only the best. These pictures of the stone winery buildings were taken in 1962.

The haunting look of the Far Niente Winery buildings is captured in these 1962 pictures.

Closed from Prohibition until the 1970s, the empty Far Niente buildings harken back to an era many years prior. The winery reopened under the direction of Gil and John Nickel. It is located just down the road from another great Napa winery, the Robert Mondavi Winery, and has been back on track for nearly 30 years. Today, it is one of the showcase wineries in the Sonoma-Napa region.

The Foppiano Vineyards were founded in Sonoma in 1896. One of the Valley of the Moons long-lived family wineries, it is located just outside of the town of Healdsburg. Its outstanding wines have long made Foppiano a favorite amongst wine tasters and its recent renovation, along with its adherence to its historic past, have made Foppiano one of the more popular stops through the Wine Country.

The façade of the Inglenook Winery, which was founded in Napa in 1879, has a stately appearance with its carved stonework. These pictures were taken of the front entrance of the winery in 1950.

Here is Joel Peterson hard at work, making sure that the wine in these barrels does not disappoint anyone who might taste it.

In 1976, Ravenswood Winery opened for business. From the start, Ravenswood found itself amongst the very best in Sonoma winemaking. Located in the town of Sonoma, its beautiful

facility is a favorite for both tourists and locals, who enjoy the warm surroundings and the fantastic wines.

Co-owner and winemaker Joel Peterson has become a significant member of the new guard of Sonoma winemaking.

In 1981, Peterson formed a partnership with Reed Foster, and the rest is history.

Looks like everyone at Ravenswood is pleased with this year's harvest!

Looks like this fellow has had one too many—bearing testimony to the long-held belief that too much of a good thing is not too good after all!

Index

Analy Bank	39	Metzger Winery	59
Annadel	37	Mont La Salle	94
Armstrong Grove	74	Monte Rio	89, 90, 91
Beringer	105	Montgomery Village	103
Bottasso and Sons	42	Nervo Winery	56
Buena Vista Winery	9, 10, 11,12, 13, 14, 15	Orr's Winery	51
Burbank, Luther	66	J. Pedroncelli Winery	48
Chateau St. Jean	4	Petrified Forest	72, 73
J. Chauvet Winery	44	Penngrove	93
Christian Brothers Winery	113, 114, 115	Peterson, Joel	121, 124, 125
Dry Creek Valley	68	*Press Democrat*	87
Duncans Mills	38	Ravenswood Winery	122, 123, 124, 125, 126
Far Niente	116, 117, 118	Raymond, Audrey and William	96, 97
Flamingo Hotel	99, 100, 101, 106, 107	Rincon Valley	59
Fountain Grove Winery	109, 110, 111	Rhododendrons	62
Foppiano	119	Russian River	6, 61
Foster, Reed	125	Rustic Inn	44
Geyser Peak	21, 22, 23, 24, 25, 26, 27, 54	Santa Rosa	2, 41, 43, 54, 58, 60, 71, 79, 82, 86 87, 88, 94, 104, 105
Glen Ellen	45, 92	Salvation Army	80, 81
Gold Rush	69	Sebastiani	32, 34, 35, 36
Grand Hotel	83	Sebastopol	46, 62
Guerneville	42, 67, 68, 84	Seghesio Winery	53
Hotel Mervyn	45	Silk Brothers	39
Highway	12, 33, 99	Simi Winery	28, 29, 30, 31
Hop Kiln	65, 67, 68	J. Shaw Winery	59
Inglenook Winery	120	Sonoma	32, 33, 38, 53, 60, 83, 85, 93, 95, 96, 97, 98, 108
Italian Swiss Colony	75, 76, 77, 78	St. Rose Church	81
Thomas Kearns Winery	50	Summit Peak Vineyards	52
Kennedy, John F.	97	Valley of the Moon Winery	56
Kenwood	47, 58	Valley View Winery	49
Korbel	16, 17, 18, 19, 20	Wymore Quarry	37
Lachman and Jacobi Winery	51		
London, Jack	39, 45		
Mansfield, Jayne	99, 100, 101, 102		